Simon and the snowflakes

Gilles Tibo

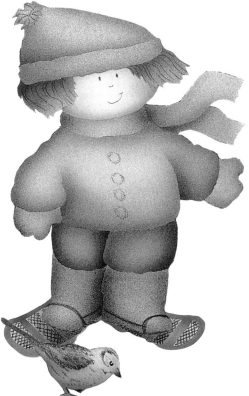

Tundra Books

My name is Simon and I love to count.

When the first snow begins to fall,
I run out to count the flakes.

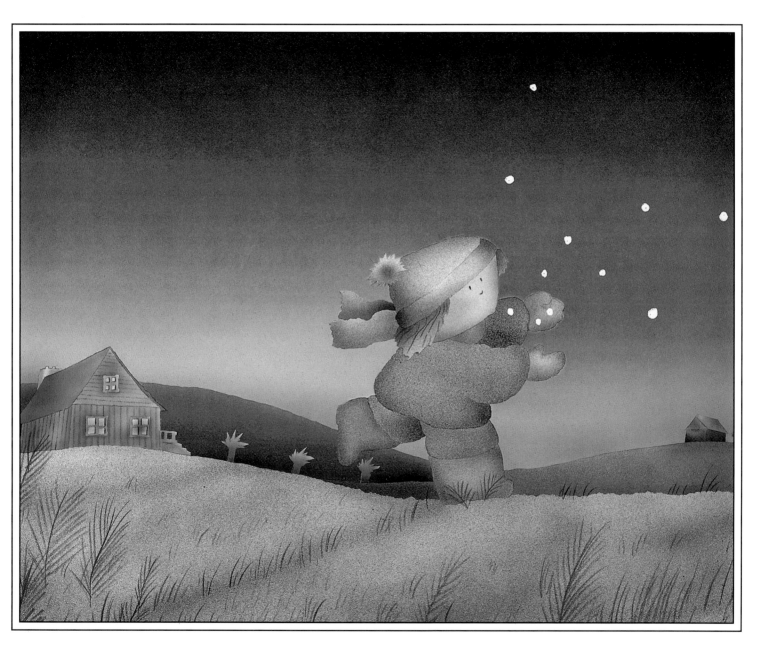

But the flakes come down too fast.

How can I ever count them?

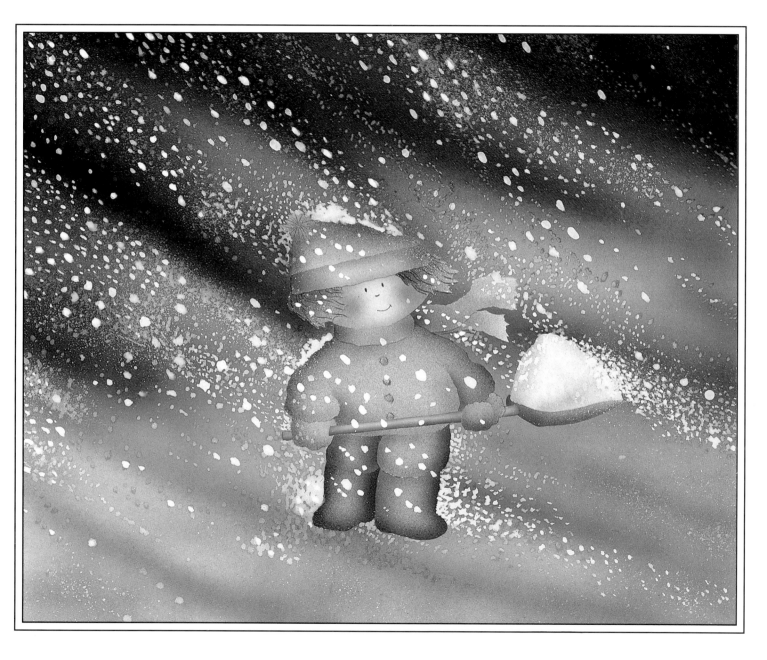

If I count the flakes that fall on a bird
And then count all the birds,
I will know how much snow falls.

I stand on a tree trunk with my broom.
But the birds fly by too fast.

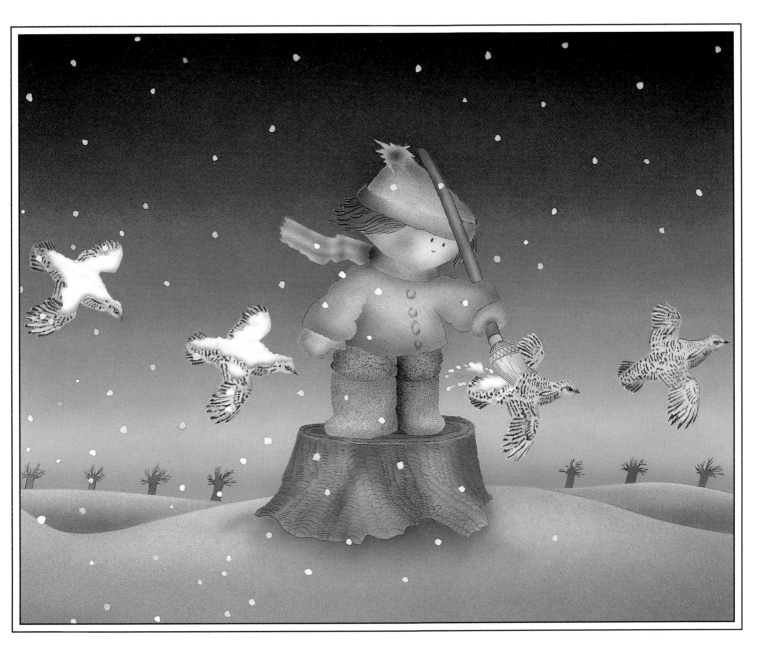

I go to a field to ask the snowman:
"How many flakes are there in a snowfall?"

"That's easy, Simon," said the snowman.
"There's a snowflake for every star in the sky."

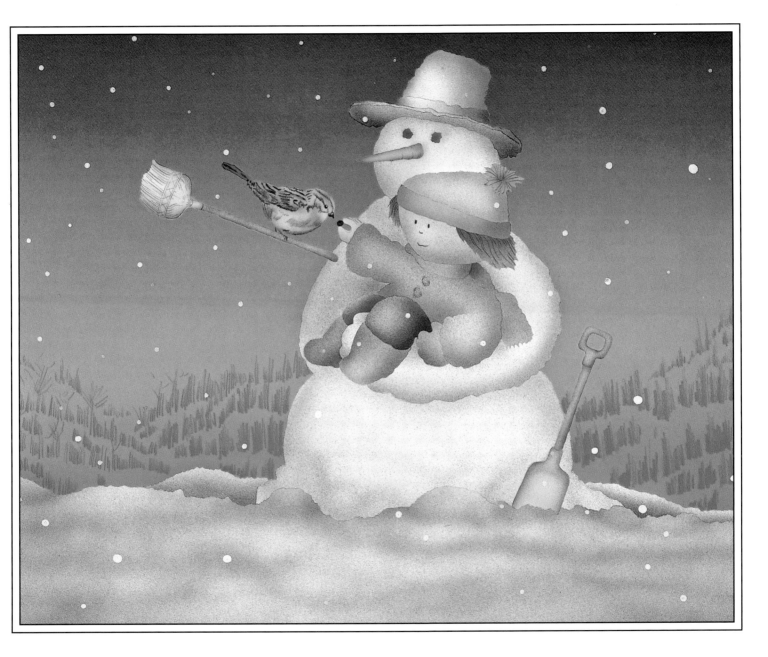

I go up a hill to count the stars.

My friend Marlene brings a ladder.
We pull down stars and count them.
We fill our toboggan with stars.

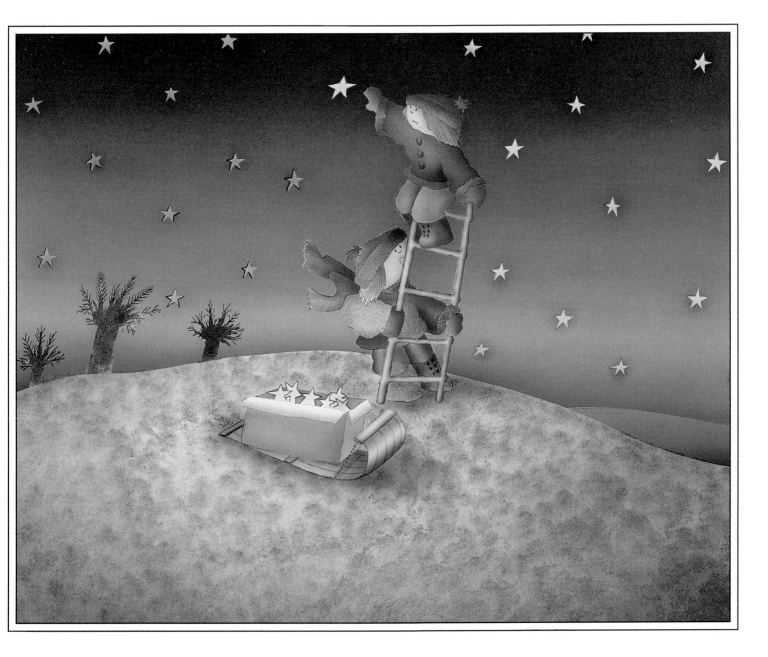

But the stars move away across the sky.

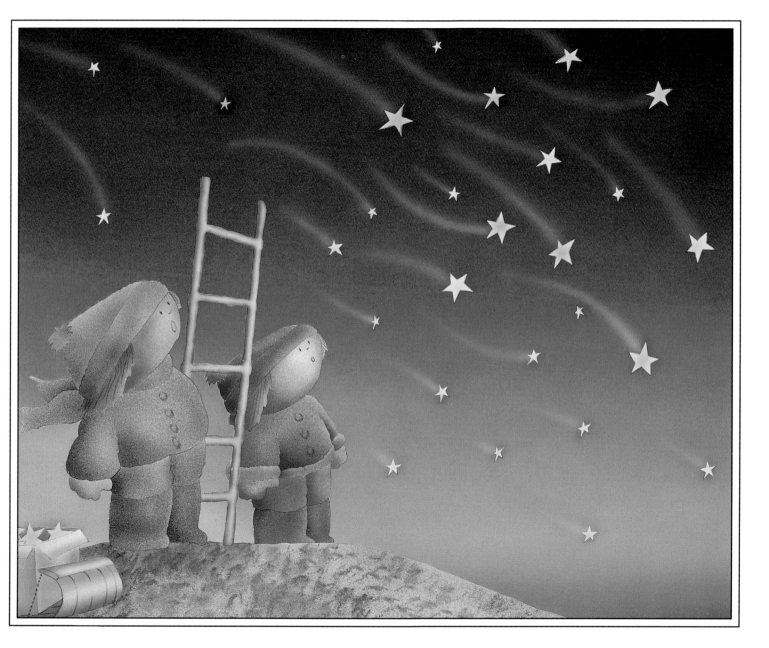

I stand on a snowbank to ask the moon:
"How many stars are there in the sky?"

"That's easy, Simon," said the moon.
"As many lights as there are in a city."

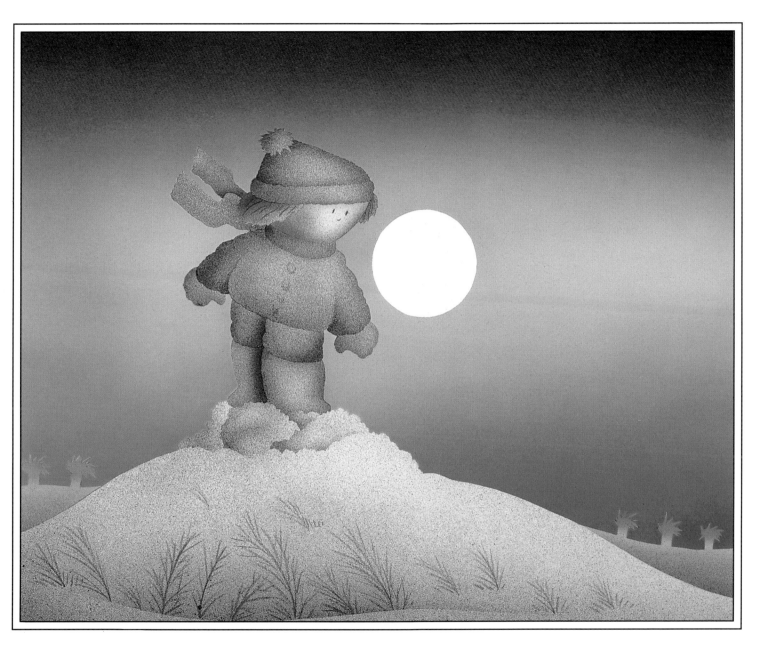

I get on my sled and ride to the city.

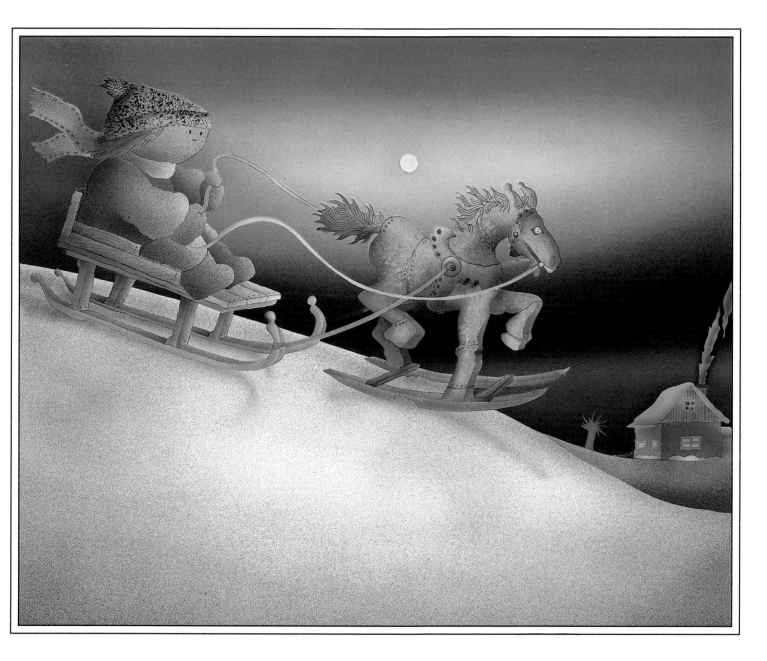

I go up a mountain to count the lights.

But the lights go on and off.

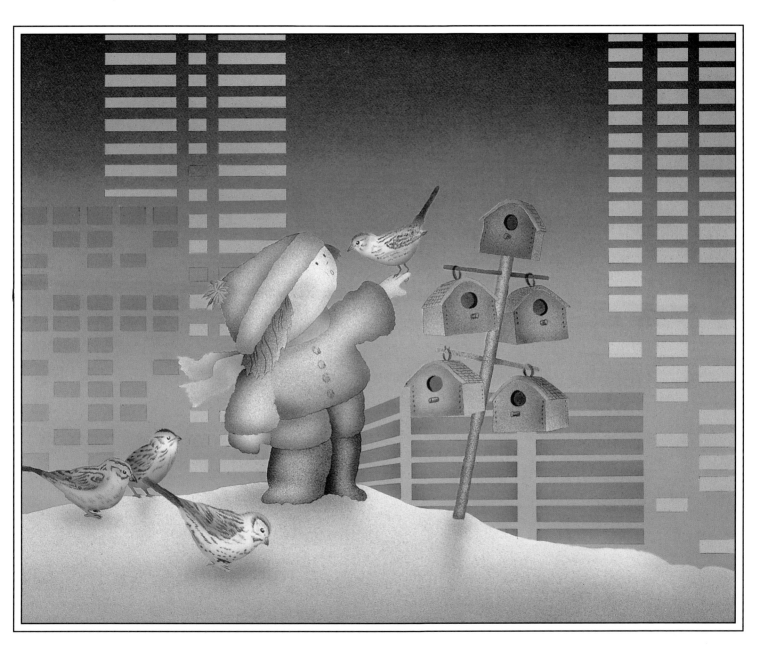

I go to the forest to meet my friends.

I cannot count the lights in a city,
the stars in the sky,
the flakes in a snowfall.

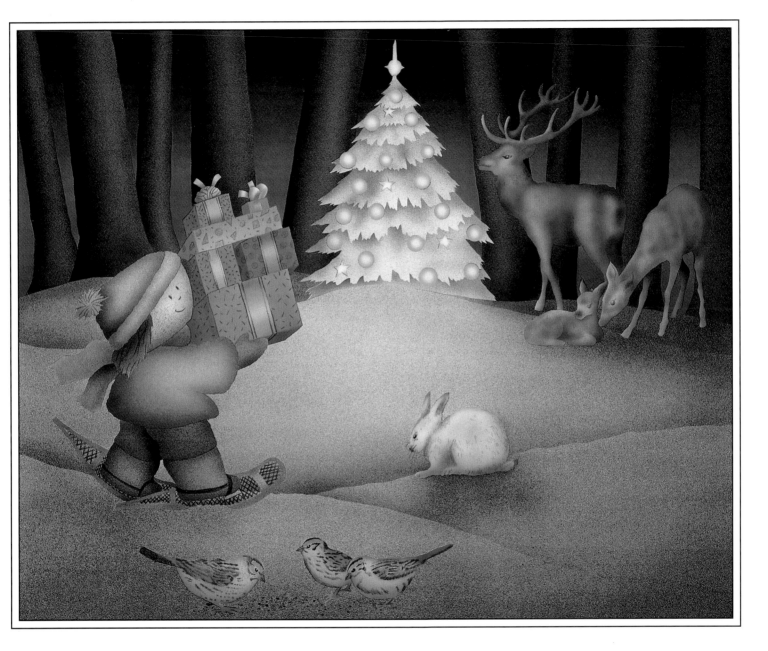

But some things I can count.

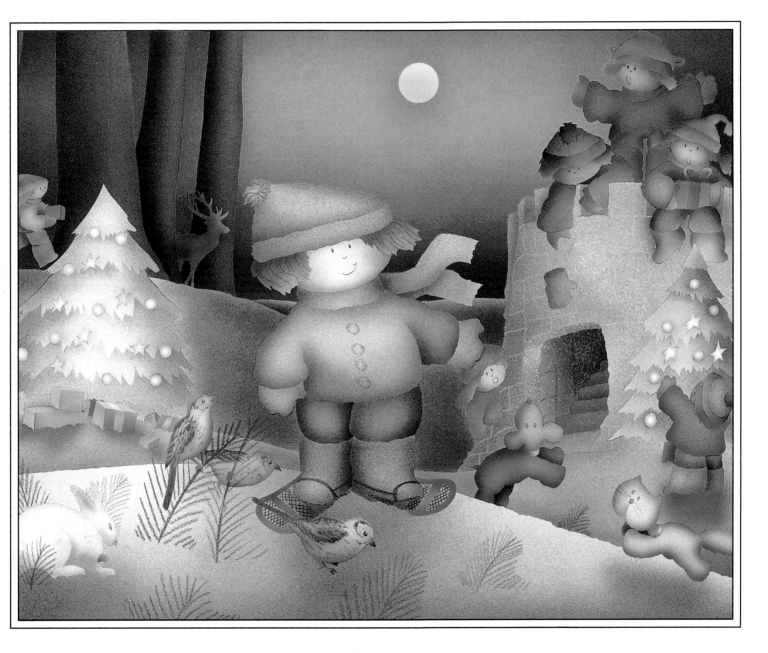

To Danielle and Marlène

© **1988 by Gilles Tibo**

First Paperback Edition, 1991
Sixth Printing, 1997

Published in Canada by Tundra Books, *McClelland & Stewart Young Readers,* 481 University Avenue, Toronto, Ontario M5G 2E9
Published in the United States by Tundra Books of Northern New York, P.O. Box 1030, Plattsburgh, New York 12901

Library of Congress Catalog Number: 88-50258

Canadian Cataloguing in Publication Data
Tibo, Gilles, 1951– .
 Simon and the snowflakes

ISBN 0-88776-218-2 (hardcover) 10 9 8 7 6 5 4 3 2
ISBN 0-88776-274-3 (paperback) 10 9 8 7 6

Translation of: *Simon et les flocons de neige*

 I. Title.

PS8589.I26S44 1988 jC843'.54 C88-090132-2
PQ3919.2.T43S44 1988

We acknowledge the support of the Canada Council for the Arts for our publishing program.

Printed and bound in Canada